MARTIN VAN BUREN:

LAWYER,

STATESMAN AND MAN.

BY
WILLIAM ALLEN BUTLER.

NEW YORK:
D. APPLETON AND COMPANY,
443 & 445 BROADWAY.
1862.

MARTIN VAN BUREN.

———••• •———

AT this moment, when our ideas are mus-
tered at the tap of the drum, and when we
are waiting for new intellects and new rep-
utations, with an impatience which speaks
our extreme need of them, the end of a life
loaded with the honors of a past generation
seems of little account. We can hardly
spare the time to cast even a glance at the
retreating figure, which, as it passes from
the stage, does not lessen the number of
actors in the foreground, who are carrying
forward, to its close, the great drama of pres-
ent events. It is only a supernumerary.

He has played his part. He goes unnoticed.

This is natural, but it is neither just nor wise. No career which has justified the principles on which our free institutions rest, and illustrated their matchless creative power, should close without its fitting tribute. No great man, whose greatness grew out of the native soil from which all that is hopeful or sustaining in the cause of freedom must draw its vital stength, should go to his grave without something more than the funeral obsequies which shroud his exit. As the great lights go out, let us pause at least long enough to retrace the orbits they have travelled, and to mark the points of their departure.

II.

"Martin Van Buren, Ex-President," says the telegraph to the second or third edition of the evening newspapers of the city, on the 24th day of July, 1862, " is dead. He was in the eightieth year of his age. He will be buried at such a time." Motions are made to adjourn such sultry courts as are kept open in the summer vacation for stray litigation. Flags are at half mast. The National Government takes due notice of the event. The daily journalists, who are apt to know, beforehand, when distinguished citizens are near their end, and keep obituary notices in type, produce their biographies, gleaned from the nearest cyclopedia or repository of names and dates. They catalogue the honors and titles of the de-

parted. It is like a merchant taking an account of stock. They sum up his claims on the public gratitude. It is like an auctioneer's estimate of the goods he is selling. The result is very much the same. The dead great man is struck off, and the next lot is taken up. Going, going, gone!

After all, this is as much as the daily journalist can do. If any man seeks a public career, let him lay it to heart that the most successful public career ends thus, and always thus, in a list of titles and an inventory of honors, a paragraph or a column, between yesterday's good news and to-morrow's bad news, for which, while men are looking, they overlook the paragraph, and the column, and the career.

Notwithstanding, let us take a closer scrutiny of this life of seventy-nine years, of which so much was passed in the service

of the State. Perhaps we shall find that
we misjudge in supposing it to be a mere
schedule of public offices and rapid political
promotions. Perhaps it was carved out by
a patient, resolute, and courageous will,
guided by an intellect which looked into
the centre of things, and into the secrets of
men.

Disengaging ourselves from details, which
do not belong to the rapid summary at
which I am now aiming—Mr. Van Buren
was a great lawyer. The foundation of all
his successes was laid in his legal training.
A professional man must be judged by his
profession. A true lawyer is always a law-
yer. If he gives himself wholly to the se-
vere discipline which is the condition of suc-
cess, and gains the secrets of that science
which, more than all other human forces,
directs the progress of events, its subtle

light surrounds him like an atmosphere, and accompanies him like a perpetual presence. If he takes the wings of the morning, and dwells in the uttermost regions of the imagination, it is there; if he makes his bed among politicians, it is there; if he says, surely the darkness of evil passions shall cover me, even there the night is light about him. The key to Mr. Van Buren's rare supremacy in his political life, lies in the sedulous and patient toil with which his intellectual powers, strong by nature, were tempered and polished in the slow processes of his professional career.

I said he was a great lawyer. This, to most readers, is a mere phrase. And, for such readers, it would not help them to a clearer meaning if they were to be referred to adjudged cases in Johnson's Reports. Let me rather try to give them an idea of

the legal career itself, which is summed up by such a phrase.

Mr. Van Buren, as we all know, was a native of Columbia County. There he learned what they could teach him at the village academy. Having few books to study, he began to study men, and then, at the age of fourteen years, to study law. He served a seven years' apprenticeship, and was admitted to the Bar. This was in 1803, just at the threshold of the present century. He was thrown at once into a society marked by the strongest traits of individual character. The hot blood of the Revolution still ran in the veins of men active in all the pursuits of life. It must find vent in some way, and it found vent partly in politics, partly in local feuds, which were fought out in the courts. Litigation was a serious matter. Political prejudices

and personal animosities found place in the jury box, on the witness stand, on the Bench, and at the Bar. The leading lawyers were the representatives of the two leading parties.

The Federalists of Columbia County, who had money, lands, and a kind of patrician pride; who believed in their own capacity to govern everybody, and disbelieved in the capacity of other people to govern themselves; who had all the property, and claimed all the power, put forward, as their champion, Elisha Williams, a man whose name is harldly known to this generation, except by professional traditions, but whose genius was brilliant enough to dispense with the light it borrowed from such patronage. He was one of those rare men whom other men cannot resist. He was invincible before juries.

He could make his hearers laugh when they felt sober, and he could make them cry when they wanted to laugh. He could make a witness tell the truth when he meant to lie, and appear to lie when he was trying to tell the truth. He got impossible verdicts, against Law, and Fact, and Reason. He was a man not to be rivalled on his own ground, or fought with his own weapons. Mr. Van Buren trained himself to meet this giant. He was his opposite in politics, in professional tactics, in the means by which he reached his own conclusions and other men's minds. It was the old story of Richard and Saladin; of the heavy weights and the light weights. The two gladiators were well matched, and the incessant quarrels of their clients brought them into constant conflict. The lawsuits were innumerable. Sometimes

they were about trifles, sometimes about
grave matters. Now it was a controversy
over a bet on a horse race or an election;
now about a fishing net misappropriated in
the shad season; now about a road, or a
farm fence, or a town line, or a disputed
title. Generally, the case fell under the head
of what, in the language of the law, is
called " trespass," which includes almost
every conceivable injury which one man
can do to another man's person, property,
or character. The Federalists of those
days were not in the habit of forgiving the
Democrats who trespassed against them,
unless they paid damages and costs, and
the law was the only peacemaker.

These hard fights did not end with the
jury trials. They went up from the Coun-
ty Circuit to the Supreme Court. That
was then an august tribunal. It was not,

as now, a mere machine for the despatch of business. Jupiter, with his thunderbolts, was not more terrible than a Chief Justice of that day. The sittings were held at the Capitol in Albany and at other central points, and the whole Bar, from every county, came up to attend them. The men who had gained local reputations, in remote districts, were brought in contact with each other, and vied for more extended honors. Albany furnished Henry and Van Vechten. The New York cases, which smelt of ships, and shops, and brokers, brought up John Wells, Aaron Burr, Thomas Addis Emmet, and other metropolitan lawyers, among whom were two men who figured in the reports as " S. Jones, Jr." and " Oakley." The county trespass suits and ejectments brought the country lawyers, and, among them, the two rival leaders of

the Columbia circuit. Here Elisha Williams could not fetch his juries. He had to fight at close quarters ; on the law, and not on the facts. The clearer intellect of Mr. Van Buren, with its keen edge of analysis and its sharp distinctions, cut through to the marrow of the case, and laid bare all its vital points. Only a short time since, in an important case decided in the Court of Appeals, I noticed that, in the opinion of the Court, an argument which might have had some show of strength, was disposed of by the suggestion, that in a leading case, argued by Mr. Van Buren, in which it would have worked in his favor, he conceded that it was untenable. This was a rare tribute. Elisha Williams himself gracefully yielded the palm, when he said, truly and tersely, to his old rival, " *I get all the verdicts, and you get all the*

judgments." This was more than a happy phrase. It was a revelation of the whole interior purpose and policy by which Mr. Van Buren sought success. He indicated it himself, in a more famous sentence, when he appealed to " *the sober second thought* " of the people. The judgment is a kind of sober second thought, after the verdict. He looked for that, and was willing to work and wait for it. But it was a surer rule in the science of the law than in the game of politics. With us, it is the first thought, or rather the first impulse, which controls. The sober second thought is, too often, only another name for repentance.

Not one of those eminent lawyers, whose names figure thus, side by side, with Mr. Van Buren's, in the books of Reports, now survives. And the chronicle of all their exploits in these keen encounters of intel-

lect, is only for professional readers. But
they had this advantage over their succes-
sors, in the same calling, that the reporter
of their time, having less material for his
volumes than the reporter of to-day, pre-
served and recorded the arguments of
counsel, as well as the decisions and opin-
ions of the Judges, so that a certain kind
of immortality waited upon their most im-
portant efforts and they had the satisfac-
tion of knowing that, so long as the law
was followed as a science, its disciples
would not fail to recognize them as pioneers
in its labyrinthine paths, to learn something
from what they taught, and to take courage
from their example.

III.

Over the long public career which, at
first, ran side by side with these profes-

sional successes, but soon drew his whole life into its swifter and bolder current, some men, viewing Mr. Van Buren from this distance, will write "*Politician*," some men "*Statesman.*" It matters little to us, whose business is not historical anatomy or political dissection. Here is a man, self-made, self-sustained, with no hereditary or accidental aids in the search for fame and fortune, who from 1812, when he succeeded in his first contest for a popular office, against a Livingston and a landlord up to 1841, when he left the Presidential chair, held in succession almost every place of trust or power known under our form of government—State Senator, State Attorney-General, United States Senator, Governor of New York, Secretary of State, Minister to England, Vice-President, President. If you count by honors, surely

these are the places which belong to statesmen. If you exact the test of popular judgment, the most substantial of all these prizes were direct gifts from the people. If you judge him by his competitors and contemporaries, no man ever had such rivals in the race for power. All the great names which stand for party issues or popular leadership in the history of our politics, since this century began, are on the roll with his. If you make measures the standard, no party leader was ever more tenacious as to his policy or more successful in securing its ultimate triumph. The Sub-Treasury was the result of the longest and fiercest political struggle between the greatest political parties we have ever seen or shall see. It took the place which he planned for it, and has stood, ever since, as stable as any other of the institutions

which are now rocking in the storm. It is no fault of the system it embodies that we are just now doing penance with greenbacks, and anticipating the new currency of postage stamps—which are to be good for everything but postage.

We would hardly hesitate long if it were Mr. Van Buren's legal record, which we had under our eye, whether to label it "pettifogger" or "jurist." His public record must settle the question as to his statesmanship.

The politics of this State of New York have always been a great deep. Few readers, now-a-days, care to explore them.

It is one of the hopeful signs of our times that political issues are shaping themselves upon such plain, broad grounds, that they are easily comprehended even by women and children. This is a substantial gain,

even though made at a fearful cost. But as
to what is past in politics, how few, even of
the well informed, could pass an examina-
tion. The most observant might recollect
there have been Barnburners and Old
Hunkers, and that, before them, were Loco-
focos. But with that remote period when
the Bucktails warred with the Clintonians,
the present generation have almost as little
concern as if it were antediluvian, instead
of being only ante-Jacksonian. De Witt
Clinton is the central figure of that period,
which seems so distant simply because the
intervening space, between us and it, is so
crowded with events and men. The fierce
struggle between the Republican party of
that day, after it had broken with De Witt
Clinton and gone off into Democracy, pure
and simple, and those who followed the
fortunes of the deserted leader, had in it

something of the gall and wormwood of a family quarrel. Out of New York it was wholly incomprehensible, although it really shaped the political destinies of the country. The amusing mishap which befell General Jackson at Tammany Hall, when he first came to New York, as I have heard him tell about it, is an illustration in point. This was in 1819. The General's laurels were all fresh, and the Bucktails had claimed him as their own. He was in their hands when he made his visit to the city. They did the honors of Tammany for their new hero. He knew more about the Creek Indians than about the Chiefs of the Old Wigwam. From what he saw with his own eyes, he probably got no further than a corroboration of Halleck's statement—

"There's a barrel of porter at Tammany Hall,
And the Bucktails are swigging it all the night long."

But as to their politics he was in the dark, except that they were Democrats and Jackson men. The Sachems feasted him and toasted him. He stood up to respond. The bosoms of the Bucktails expanded in anticipation; they were full of enthusiasm. They had only one passion which was stronger than their affection for Jackson, and that was their hatred of De Witt Clinton. The General, who was never much of a speech maker, thought on this occasion that he would do the handsome thing in the way of a toast. He knew he was in the great State of New York, and that De Witt Clinton was its Governor. He had heard of the Erie Canal. He had a notion that De Witt Clinton was popular. He knew that he was a man of whom they ought to be proud all over the State, and he concluded that they were

proud of him at Tammany. So he gave
" *De Witt Clinton: to be great is to be
envied!* " The effect may be imagined.
It was as if some one should propose the
health of General Butler at a matinée of
the " ladies " of New Orleans. The up-
roarious Bucktails were struck dumb. The
General sat down in silence. He applied
to the nearest Bucktail for a solution, and
found out his mistake. But he let the
toast stand. This reminiscence he enjoyed
vastly as he recounted it. " What should
I know," he said, " about their politics ? "
His business had been to fight, and not to
raise or feed party issues to sustain a repu-
tation in advance of his successes. The
next toast he ventured was on surer
ground. It was at a table where he knew
the company better than he knew the Tam-
many Bucktails. They were Southern

nullifiers and their sympathizers. Jackson threw down the gauntlet to them in a toast, *Our Federal Union: it must be preserved!*—the best after-dinner sentiment ever uttered. Was it a toast or a prophecy?

Just here, General Jackson's first impressions of Mr. Van Buren are in place. They met in 1823, at Washington, as Senators of the United States. The Tennessee Senator soon formed his opinion of the New York Senator. I will give his own narrative, as I listened to it under the porch of the Hermitage in 1844. "I had heard a great deal about Mr. Van Buren," said the General, "especially about his *non-committalism.* I made up my mind that I would take an early opportunity to hear him and judge for myself. One day an important subject was under debate in the

Senate. I noticed that Mr. Van Buren was taking notes while one of the Senators was speaking. I judged from this that he intended to reply, and I determined to be in my seat when he spoke. His turn came, and he rose and made a clear, straightforward argument, which, to my mind, disposed of the whole subject. I turned to my colleague, Major Eaton, who sat next to me : ' Major,' said I, ' is there anything non-committal about that ? ' ' No, sir,' said the Major." This decision of Jackson's head was never reversed by his heart.

Non-committalism was the standing charge against Mr. Van Buren. This man, who had committed all manner of political crimes, had never committed himself. From the time that the Hudson Federalists gave up trying to convert him, finding that he was a predestined Democrat, they began

2

to call him hard names. When the Whig party administered on the estate of the Federal party, it succeeded to its entire stock in trade of abuse. It had assets enough in the way of epithets to set up half a dozen Parson Brownlows. Mr. Van Buren was a fox, a snake in the grass, a little magician, and whatever else in animated nature symbolizes cunning and malice. We can see now how all this helped him, as he ran the gauntlet of vituperation, straight into place and power. Abuse is the healthiest diet for a politician. Besides, this throwing stones at character was a game that two could play at, and both parties played at it. A very lively game it was too, as they carried it on.

All along, the blunders of Mr. Van Buren's political opponents in respect to him were greater than their crimes. They

set Elisha Williams on him when he was struggling for a position, and this roused him into strength. De Witt Clinton removed him from the office of Attorney-General; this made him a martyr, and he rallied his partisans to avenge the wrong done to their cause in his person. A similar blunder, on a larger scale, was his rejection as Minister to England by the Senate. This made him Vice-President, and helped to make him President. They should have seen, what the history of his life shows plainly enough now, that while they called him non-committal, this was a mere criticism on the caution of his style and conduct, and that in the political ring he dealt his blows fairly and squarely, and always came up to time. He was essentially independent, and would stand by himself when his judgment led him to differ from others. He

resisted the efforts of his early patron and
partner to draw him into Federal alliances.
He supported Clinton in 1812, against his
friends. He entered the lists in a legal
controversy with Chancellor Kent on the
question of what was called the Classifica-
tion bill, a favorite war measure for a spe-
cies of drafting. He advocated the claims
of Rufus King, a Federalist, for Senator
of the United States in 1819. He would
not bid for popularity by surrendering his
objections to universal suffrage in 1821,
nor by joining in the " Lone Star " cry for
the annexation of Texas in 1844.

He had, it is true, the best aid in all his
plans. Cool heads and well-trained hands
organized all the victories of the Jefferson-
ian-Jacksonian Democracy. Viewed as a
party, it was a grand power. The Albany
Regency has been slandered in its day and

generation. But the men who made up that famous junto were not only able and adroit, they were honest in public as well as in private life. If they took office, they left it as poor as they went into it. They had sense enough to know that, when they were in power, they could be served better in places of trust by their friends than their enemies, and that, when their principles were in the ascendant, they could be best enforced by those who believed in them. And they acted accordingly. But, in the main, they put forward strong men. Mr. Van Buren was their strongest man, next to General Jackson, and they put him forward in his turn. His turn in the Senate was when Clay, and Webster, and Calhoun, and all the others by whose greatness we measure our glory, were in their prime. To disparage any one of these

great men, is to disparage them all. If Mr. Van Buren had had fifty regencies to back him, it would not have availed in such a field, and with such foes. He stood on his own merits, and by these he won.

The most signal triumph of his long political course was when the Senate, which by a single vote, and that the casting vote of Mr. Calhoun, had rejected him, in 1832, as Minister to England, received him, by the will of the people, as its presiding officer in 1833. The whirligig of time had brought a swift revenge. This was a rare instance of what we are fond of calling poetical justice, and was a success which seems admirably in harmony with his patient and deliberate methods of approach to the objects of his ambition.

According to the popular view of it, Mr. Van Buren's Presidency was a prolongation

of General Jackson's term. It was twelve
years, instead of eight, of the same Ad-
ministration. The old issues had been set-
tled, and no new issues were developed.
Mr. Van Buren "followed in the footsteps
of his illustrious predecessor." The prede-
cessor had been too illustrious, and his foot-
steps had so shaken the whole social sys-
tem, that a great shock was inevitable.
Not that General Jackson or his Adminis-
tration were in fault for the commercial
convulsions of 1837; but, in the nature of
things, after a contest such as that which
had been waged during his Presidency, a
mighty reaction must sooner or later have
come. The strong forces were spent which
had driven the flood of Democratic suc-
cesses to such a height, over all the break-
ers and against the giant undertow. When
the ebb came, the tide went out with a

great rush. The triumph of the Whig par-
ty, in 1840, was not a victory of opinions or
of men, but of Log Cabins and Hard Cider.
As Elisha Williams would say, the Whigs
got the verdict. Four years afterward, the
Democrats got the judgment. Unluckily
for Mr. Van Buren, between the verdict
and the judgment, there was no stay of pro-
ceedings.

Mr. Van Buren's political career ended
in 1840. I know that he was before the
convention in 1844, and before the people
in 1848. But nothing came of either can-
didacy, so far as he was concerned.

In 1844 he was fairly entitled to the
nomination of his party. It was due to
him, if ever anything is due from a party
to a leader. But he was the victim of a
National Convention. Since then we have
found out the wickedness of which such

conventions are capable; how they strangle the men whom they were expected to crown, and how they plot against the existence of the nation while pretending to select competitors for its highest places.

The Free Soil campaign of 1848 is fresh enough in recollection to need no historian as yet. Mr. Van Buren's name was in it, but not his head nor his heart. Great words were inscribed on its banners—" Free Soil, Free Speech, Free Labor, and Free Men." But they were words of advance and not of strategy, and Mr. Van Buren was too deeply intrenched in his old political notions to utter them in earnest. The Free Soil movement, in fact, meant more than was dreamt of by most of those who set it in motion. Some of its promoters were in it from principle; some from association; some out of revenge; some as a

mere game of Albany politics, directed by a Regency of a later date, carrying on business at the old stand, but who were apt to substitute bad whiskey for old Madeira. Only a few, perhaps none, saw the end of this beginning, or caught a glimpse of what was behind the veil—the tumult and the battle, the confused noise of the warriors, and the garments rolled in blood. As to many of them, they had no faith in the work they were doing for freedom. They were like the incredulous Samaritan who was very anxious for the destruction of the army of Benhadad, chiefly on account of its large supply of provisions, but who did not credit the prophecy which foretold it. They saw it with their eyes, but did not eat thereof. These were merely the advanced couriers of a progress, in whose triumphs they were not to share.

IV.

After all, it is not the lawyer nor the statesman, but the man, of whom we must take the final account. Mr. Van Buren, in his personal traits, was marked by a rare individuality. He was a gentleman, and he cultivated the society of gentlemen. He never had any associates who were vulgar or vicious. He affected the companionship of men of letters, though I think his conclusion was that they are apt to make poor politicians and not the best of friends. Where he acquired that peculiar neatness and polish of manner which he wore so lightly, and which served every turn of domestic, social, and public intercourse, I do not know. As far as my early recollections go, it was not indigenous in the social circles of Kinderhook. I do not

think it was essentially Dutch. It could hardly be called natural, although it seemed so natural in him. It was not put on, for it was never put off. As you saw him once you saw him always—always punctilious, always polite, always cheerful, always self-possessed. It seemed to any one who studied this phase of his character as if, in some early moment of destiny, his whole nature had been bathed in a cool, clear, and unruffled depth, from which it drew this life-long serenity and self-control.

If any vulnerable point was left, I never discovered it. It has been conjectured that Aaron Burr, who was in great social as well as professional repute at the time Mr. Van Buren first came to New York as a student at law, and whose hands were, as yet, unstained with the blood of Hamilton, was the model after which he

copied. If this be so, he improved on the original, for Mr. Van Buren's manner had in it nothing that was sinister, or which roused suspicion. His imperturbability was most remarkable. He never seemed to do anything on impulse, nor to be taken by surprise by events that were the most surprising, nor to be elated by those which were the most exciting, nor to be disconcerted by those which were the most untoward. He was, to outward appearance, at all times the same, in all the essentials of good breeding and a proper self-respect; as much so when he took his seat as Vice-President, in the Chair of the Senate, over which he had triumphed, or when he repeated the oath which inaugurated him in the Presidency, as when, at the close of the day which decided the election of Harrison, he heard the urchins of Washington re-

3

peating, about the White House, the fa-
vorite Log Cabin refrain, " *Van, Van, is
a used up man.*"

Toward his political opponents he was
always fair and even liberal. He kept on
good terms with all of them. If he did
not follow Cardinal Wolsey's maxim, and
cherish the hearts that hated him, he was,
at least, as courteous to them as if they
were not in the habit of abusing him in
public, and slandering him in private. This,
in the main, was an effort of policy, but there
was in it something of magnanimity. Once,
at least, all his native reserve and studied
reticence gave way, before a gush of feel-
ing, not at the misfortunes of a friend, but
at the fall of his most dreaded rival.
When De Witt Clinton died, Mr. Van Bu-
ren was at Washington. A meeting of
Senators and Representatives was called to

pay a tribute of respect to the memory of the great statesman. Mr. Van Buren spoke, in words of warm eulogy, of his great and signal services, and the gratitude they should inspire, and then added : " For myself, sir, so strong, so sincere, and so engrossing is this feeling that I, who, while living, never, no never, envied him anything, now that he has fallen, am tempted to envy him his grave, with its honors ! " Hardly anything could be finer than this.

It was another of the charges against him that he was no Democrat. He dressed too well, he lived too well, the company he kept was too good, his tastes were too refined, his tone was too elegant. So far as Democracy is supposed to have an elective affinity for dirt, this was all true ; he was no Democrat in taste or feeling, and he never pretended to be. The only President

who ever betrayed the American people,
is the only one of whom I remember to
have seen it chronicled in the newspapers,
as a proof of his democracy, that he made
a parade of getting out of a stage-coach in
the course of a hot journey, and washing
his face in a tin basin and drying it on the
tavern towel. The people thought no bet-
ter of him for that bit of deception, which
deceived nobody.

Mr. Van Buren never played such tricks
as these. As to the elements of the widest
popularity, they were not in him. He
never inspired enthusiasm, as Jackson did,
or Henry Clay. The masses accepted him
as a leader, but they never worshipped him
as a hero. He is not canonized in their
affections. The day of his birth will not be
commemorated in distant cities or in re-
mote periods of time. His name will never

be a watchword. Yet he had many devoted friends, among men who never wanted office, and who drew closer to him in his retirement than when he was in power. This much I can testify, that on the part of one man, than whom no purer or nobler ever lived, he was the object of an affection so true and steadfast, so faithful through good report and evil report, so loyal to its own high sense of duty, so tender and so generous, that it could never cease to command my admiration, if it had not long ago claimed my filial reverence. Seen through a medium so pure and tranquil, the traits of the character I have attempted to draw are all tinged with its mellow light and glow with its genial warmth, and the faults or failings which another and perhaps a juster scrutiny might disclose, fade out of sight.

His retirement was dignified and ex-Presidential. He withdrew to his native soil, and there settled, contentedly, among the farmers and farm houses of Columbia County, the possessor of a larger farm than his neighbors, and a larger house, as was his right. Here it was evident at once that he was not likely to die of a defeat at an election or the casualties of a National Convention. He took no grudge against the country for having refused him that second term which was all that was needed to round with completeness the full circle of his ambition. He spent a score of years in this seclusion, varied by occasional visits to old friends and an extended tour in Europe; and among his books, his neighbors, the friends whom he attracted to the genial hospitalities of his house, and the rural pursuits, which he followed with characteristic

regularity and method, he passed a tranquil old age, outliving by a decade what Elisha Williams used to call the " Almighty's statute of limitations."

v.

On the day of the funeral, we drove over the dusty road from Hudson to Kinderhook, past the yellow fields, just ready for the harvest, which rolled from the river, eastward, toward the heart of the fertile country. How fertile it had been in great men, the greatest of whom had just been gathered by the reaper, Death! We skirted the wide lawns of Lindenwald, across whose sunny sward the last shadow of the funeral train had already passed. As we came nearer to the journey's end, the roads were all astir with the motley crowd of country vehicles, pressing toward the same centre.

The village was as full as if some weighty
agricultural interest were at stake, or some
gala day had called all the county togeth-
er; only the flag over the green was at
half mast, the bell was tolling, and the peo-
ple wore a serious air. In the old Dutch
church, more thronged, I presume, than
ever before, the funeral services went on.
The village choir sang the old-fashioned
requiem, given out as the Ninetieth Psalm,
second part, which tells us, in words as
mournful and as true as when David first
breathed them in Hebrew to his harp, or
Dr. Watts diluted them in English verse,
how

> " Time, like an ever rolling stream,
> Bears all its sons away."

The clergyman, with rare good sense, for-
bore to eulogize, so near the brink of the
grave, and taught the graver lessons of pa-

triotism and religious truth which the hour
demanded. Afterward, the coffin lid was
opened, and the vast concourse of people
passed slowly by and looked their last on
the face of the dead. All was done decent-
ly and in order. It would have been hard
to find a procession in which were mixed
more of the elements of sterling manhood
and womanhood than in that which thus
took leave of their old friend. Rustic beau-
ties, not a few, with faces half flushed with
the excitements of a public occasion, half
sobered with its sadness ; wholesome, mat-
ronly women ; hale men, who would have
delighted the eyes of the recruiting ser-
geant, and veterans as old or older than
the departed. All seemed moved with a
common and sincere grief. This was the
best tribute that could be paid. They felt
that they too had shared in the honors of

their statesman. His fame had made all
their neighborhoods famous. He had been
the link by which that quiet inland centre
had been bound so long to the great world
beyond, and now it was broken. Our sor-
row is never so sincere as when it is a part
of ourselves that we have lost.

Mr. Van Buren has left memoirs, partly
finished. If his reminiscences can be given
to the world as he was in the habit of giv-
ing them to his friends, in all the freshness
of familiar intercourse, they will be most
attractive. There was a charm about his
conversation, when it turned on the inci-
dents of his personal experience, which
could hardly be transferred to the printed
page, so much of its interest depended on
manner and expression. Mr. Van Buren
had no wit, but he had humor, and a keen
sense for the humorous, and he could re-

produce, with rare fidelity, whatever in the actions or the characters of men he had thought worth remembering. It is to be hoped that out of the material he has left for such a work, we may have one that shall represent to us something of the real activities and interior lives of those of whom we know so little beyond their names and titles, so that they may seem to us more like living men, and less like mummies. At this present moment, we could hardly stop to read such a book, no matter how vivid and lifelike. But after the storm and the earthquake are over, and we have learned to value the Republic by what it has cost us in brave lives, we, or eyes younger than ours, will turn with new interest and delight to whatever in literature or in art shall be commemorative of those who have served it best.

3477-2